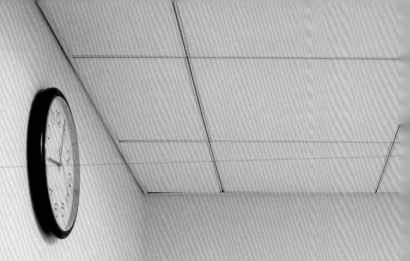

# OFFICE MAYHEM

# A HANDBOOK FOR PRACTICAL
# ANARCHY IN THE WORKPLACE

Juliette Cezzar

**A JACK SPADE BOOK**

Abrams Image  **NEW YORK**

Editor: Eva Prinz
Designer: e.a.d.
Production Manager: Jacquie Poirier, MacAdam Smith

Library of Congress Cataloging-in-Publication Data

Cezzar, Juliette.
  Office mayhem : a handbook for practical anarchy in the workplace /
Juliette Cezzar.
      p. cm.
  "A Jack Spade book."
  ISBN-13: 978-0-8109-9387-7
  ISBN-10: 0-8109-9387-2
  1.  Work—Humor. 2.  Offices—Humor.  I. Title.

  PN6231.W644C49 2007
  650.02'07—dc22

                    2007030836

Printed and bound in China
10 9 8 7 6 5 4 3 2 1

# HNA

## harry n. abrams, inc.

a subsidiary of La Martinière Groupe

115 West 18th Street
New York, NY 10011
www.hnabooks.com

# CONTENTS

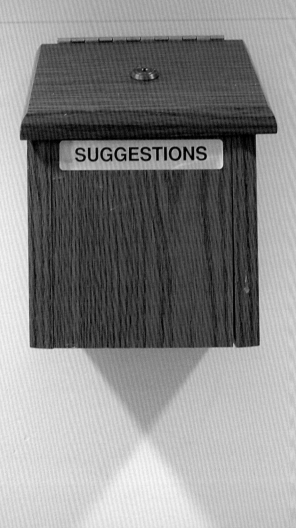

# MANIFESTO

Workers of the world, unite. The tyranny of the workplace has nothing to do with your boss. Getting a coworker fired will not help. Your boss and your coworker are part of the vast conspiracy to first alter your mind and then destroy your world. You think that things are different on another floor or in another city, or if you had another job. It's not true. The machine is everywhere and nowhere, it is the holy ghost you hear buzzing in the fluorescent lights, beeping and flashing through the phone system, and flickering

over computer monitors. The debris is every-where, piled in boxes and on desks, the false universal of binder clips, rubber bands, ball point pens, and file folders. These things were once the tools of your oppression. Here they become a deadly arsenal in the war against the granddaddy of all systems of control.

Your office is both a physical space and a mental one. The word "office" is derived from the Latin *officium*, which originally referred to a "bureau," but not a physical space. The term was used to signify a dignitary's staff of collaborators and administrators. And, of course, "bureau" forms the root of the word bureaucracy. In the pursuit of office mayhem, it's important to remember that these centuries-old human systems need to be corrected. The problem lies in the bedrock

of Western civilization. It's also important to remember that any organization that rises in opposition to an office culture will generally organize itself into a unit that takes on those same characteristics. Office mayhem, therefore, like any anarchic movement, starts and stops with the individual. While it is of course mutually beneficial to unite with others who believe in the same cause, and beneficial, too, to help others recognize how very necessary it is to resist all systems of control, beware of any organized movement that purports to have a catch-all manifesto.

The would-be office anarchist will also find that it can be useful to acquaint oneself with the breadth of forces that come together to create office culture and the process by which it spreads. The oppression starts

outside of the office, in the form of constructed desires and needs and dire consumerism; and it is reinforced through every form of cultural production that is not purely individual.

This pressure does not come about solely from advertising or television, but from the air you breathe, your family, your friends, your schoolmates. Many people manage to question these imperatives in adolescence and early adulthood, but most will succumb within two or three years of working full-time. The result is akin to a severe (and mass) attack of zombification: People you once knew as fellow strugglers in this zombie world will start talking about mortgages, furniture, baby showers, five-year plans, and promotions. You know that the process is complete when they utter the key phrase that baptizes them into this universe of paper clips and cubicles:

"It is what it is." Unless there is reason to think they can be released from the zombie state, you must refuse to associate with them further, or you will become one of them.

This is only the beginning; within the office, there is a wide range of believers and enforcers, and it is important to be able to identify who they are and what their level of influence and importance is. Much of workplace oppression is laid at the feet of those in charge. While this is true on a metaphysical level, they are not the foot soldiers of the regime. Successful resistance does not involve marching into the boss's office and laying down a set of demands. It has to do with slowly breaking the will of the enforcers and those who spread and reinforce the ideology of the irreversibly undead. The

enforcers are almost always "support" staff members. This includes office managers, receptionists, secretaries, and information technology workers. Make no mistake here. They are dangerous. These people are bloodthirsty, having been starved by the same machine that employs them.

There is a second incentive that is not to be ignored. It is, of course, power. Given the opportunity, people will take control of anything, as long as it has some level of symbolic importance, even if it is just a coffee station or the inner life of a refrigerator. This strain of power is communicated through signs and memos that state and restate a set of byzantine and ever-changing "rules" that have no real purpose but to perpetuate the controller-controlled relationship until that

dynamic dominates all your waking hours. When these rules are flouted, more insidious forms of microfascism come into play. Leave that coffee stirrer on the counter and you will find that your ID card "mysteriously" fails to work, messages do not arrive on your desk, and the forms you had to fill out because of the "new rules this year" are missing your middle initial and therefore need to be resubmitted. You will find your reimbursables unacceptable because you used staples instead of paper clips. These are the tactics of the militia of the machine that will always try to match acts of resistance with acts of control.

Those who spread and reinforce the ideology are staff members who are of the emotional contortionist variety. They are bland enough to

appear harmless, and thus rise through the ranks by virtue of a general tendency to be relentlessly positive and supportive. These automatons of balance and behavior are not a danger to you as individuals, but they will slowly convert neutral players through example and repetitive reinforcement. What sounds like a perfectly friendly question at the water cooler can be the first of a thousand that will drive you to the conclusion that you have failed in the project of adulthood and that you need to "Get your shit together."

The ideology is colorless and seemingly harmless. This only serves to strengthen its power. While the agents of sameness and predictability do not work with the same visibility and speed as the microfascists you spend most of your time thinking about, they have a wider impact over a longer period of time. They

take much longer to take down and require much more sophisticated tactics. If the first group represents the foot soldiers, this is the elite guard, and without them, the first group would have nothing to enforce.

With this book, you will recognize all of the elements, both physical and psychological, that comprise the terrain of your battle. Stay strong and use what you have at hand, from physical implements to commmunications psyops. Stay underground as much as possible, and be aware that in your efforts to cloak your activities, you may start to think that a cupcake party in the conference room is a capital idea. It never is. The resistance starts and ends with your individual fight. Know that there are others out there. Good luck.

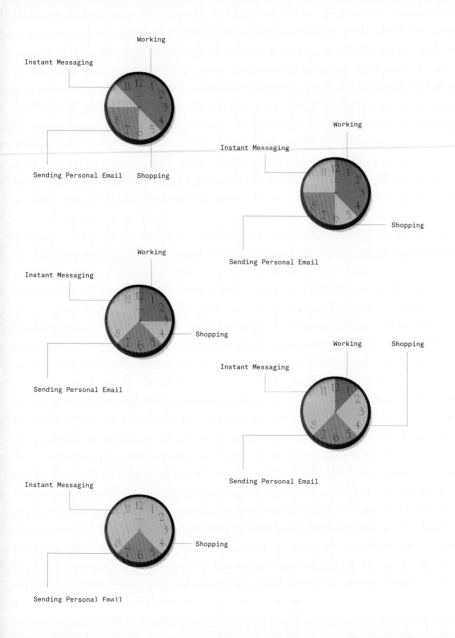

Working

Instant Messaging

Sending Personal Email    Shopping

Working

Instant Messaging

Shopping

Sending Personal Email

Working

Instant Messaging

Shopping

Sending Personal Email

Working    Shopping

Instant Messaging

Sending Personal Email

Instant Messaging

Shopping

Sending Personal Fmail

# STRATEGIC APATHY

Strategic apathy is an easy first step toward the creation of office mayhem. Before moving into the more discoverable tactics, it's important to begin destabilizing your office environment through the misuse of time. After all, if you are like the majority of people in today's workforce, your contribution is measured in minutes and hours and days and years, all counted, catalogued, and "compensated." In most cases, no one other than your boss actually knows what you are supposed to be doing; if you look busy, it will be assumed that you are working. You must resist the urge to waste time online—while this can be entertaining, you may pick up collegial news or gossip that will make you susceptible to office conversation. Set aside an exponential number of hours each day to work on your own projects and use items available to you in the office to complete them. Before long, you will have a collection of items that will display your commit-ment to not doing the work you have been given.

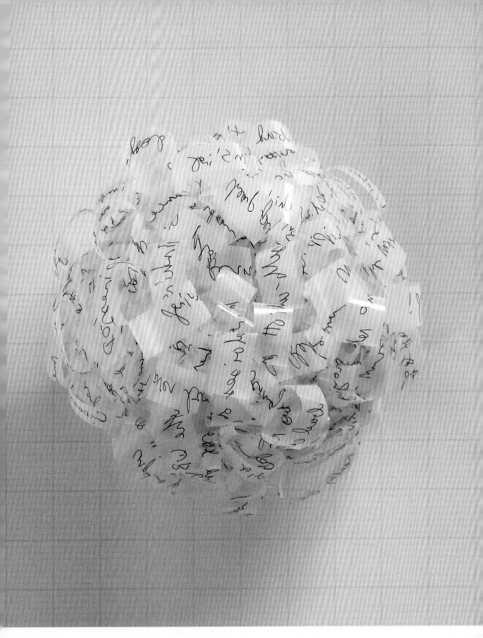

**TAPE BALL.** Simply write your gripe on the outside of a length of Scotch tape, roll into a sticky loop, and add to the ball. With time, it will grow. Display it prominently. Misinformation within could be useful to throw off busybodies.

| | |
|---|---|
| 9:00 a.m. | Never show up at this time |
| 9:05 a.m. | This is the earliest you should arrive at work |
| 9:10 a.m. | This is the preferred time to arrive at work |
| 10:00 a.m. | Eat snacks and check email |
| 11:00 a.m. | Take a break and seek cubicle conversation |
| 12:00 p.m. | Research places to eat lunch; start tape ball |
| 1:00 p.m. | Leave for lunch |
| 2:30 p.m. | Return from lunch; check email and gossip blogs |
| 3:00 p.m. | Leave the office for coffee or snacks |
| 3:30 p.m. | Bring coffee and/or snacks back; check email |
| 4:00 p.m. | Continue work on tape ball |
| 5:00 p.m. | Go home |

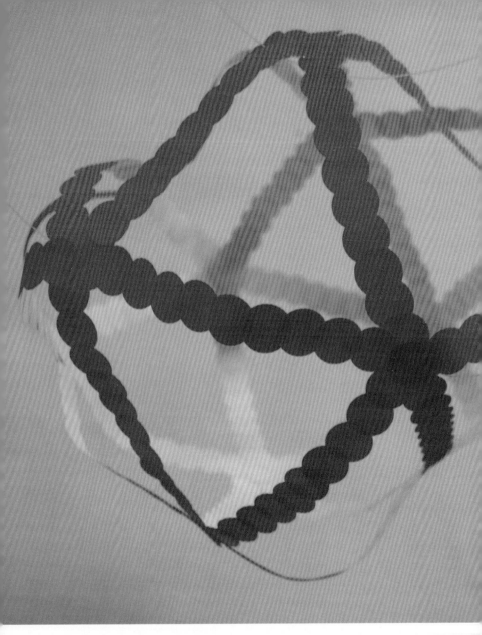

**LABELING DOTS TENSEGRITY SPHERE.** Interlocking triangles connected in pentagular formations will resolve into a flexible sphere. Several interlocked spheres will provide cover for further office time "interventions."

gardening-related material to a wide range of publications, including a hi
...opping magazine, women's magazines and gardening markets.
...aac Asimov, the successful science-and-space writer, is a classic examp...
...alist. He has the entire universe to play around with, and certainly no one...
...e him of being boxed in by his subject. Julia Child is another writer wh...
full advantage of her culinary interest/expertise, turning out a stream of...
...t you don't have to be a scientific whiz . . . or any kind of whiz, for that ma...
...be a specialist. Believe me, my reputation as a garden writing special...
...ps my actual gardening abilities (which is not to say that I'm a plant-killer...
...arden, and well enough to have done field trials for seed companies for...
...ree years). The difference is that I have developed a considerable bank...
...tion sources ranging from home gardeners (great for anecdotes!) to unive...
...ors. I have educated myself well beyond the level of the average garde...
...w much of an expert must you be to qualify as a specialty writer? Less th...
...ght think. It all hinges on the strength of your files and Rolodex. After all...
...ulina Lederer never claims to be a trained psychologist. Better known as...
...s, Lederer regularly consults experts in the process of turning out her po...
...-running . . . syndicated advice column.

## ...ialist ... s. Generalist

...may not ... t have the confidence or the credits of an Ann Landers, but a...
...st you'll ... on realize many benefits. I've found that breaking in as a spec...
...rovide a ... ortcut between writing-on-speculation and getting firm assig...
...th kill fo ... spec-writing often is a necessity for beginners trying to break...
...ghly co ... etitive marketplace. But, the word "specialist" has a way of peri...
...interest ... wary editors.
...goals of the specialist are similar to those of the generalist writer, regar...
...nore and higher-paying markets. The difference lies mostly in outlook and...
...while the generalist takes the "shotgun" approach, wading into each ne...
...oject through ... relatively uncharted waters, the specialist consolidates the...
...honing a ... ubject area that is familiar to him.
...pecialist also has an advantage over the generalist in that nearly all his w...
...arch for one article can be turned into grist for future stories. I once use...
...from a tree-planting article to add punch to a piece on mail ordering tree...
... to juicing up my regular monthly column in *Organic Gardening*. Unlike...
...nerally, well of readily available sources.
...bec ... se I've worked both sides of the street. I started out as a generalist...
...three ... ess of hard work, I was *still* starting out.
...t in desperation, and totally by accident, I turned an avid gardening hobb...
...ng specialty that has since netted scores of sales in more than a dozen di...
...ications. Within a year of pinpointing and focusing my specialty, editors...
...y beginning to call *me* with unsolicited assignments, including a month...
...n a nationally published gardening magazine. Which goes to show that...
...hungry for material, regardless of the rejection slips that might glut you

...w do you convince an editor that you are a specialist? The same way you...
...m that you are a writer, period. By firing off an intriguing, attention-ge...
...etter describing your proposal, including your special qualifications for...
...you're proposing a wildlife-related story and have worked for years at a...
...e then, by all means, say so. If your idea is on increasing your car's gas...
...it. And it goes without saying that if you already have published credi...
...alty—even one—they should be mentioned.

# The Case for Generalists
## BY GARY TURBAK

The writing world is full of choices. Should you write for adults or for children? Fiction or nonfiction? How about humor? Should you write about your own experiences or someone else's?

Or, is it possible to do all of these? Should you—can you—be all things to all editors?

...even remote.) ...st specialists a story idea ... o you. My most lucrative article idea (the p...
...lem of missing children) came out of my morning newspaper. From that one ti...
...newspaper story I ended up writing two major articles which netted me about
$5,500, including reprint fees.

Watch and listen to news broadcasts and other informational programs on television and radio. Which topics are hot? If "Sixty Minutes" is doing a piece on medical quacks today, you may land an assignment to write about them next week. Stay informed.

Listen to the people around you. If you hear, as I did, two retailers complaining about the number of bad checks they receive or buzzing about the advantages of barter clubs, you'll know, as I did, that you've just been handed a couple of article ideas.

**STASH BOOK.** Carefully carve out a compartment in a thick book and place this book on your cubicle storage shelf. Tedious and useful. Store contraband and explosives for later use.

**OFFICE SUPPLIES TREBUCHET.** Paper clips, a roll of Post-it notes, and Scotch tape, when assembled properly, can launch small objects across a room. Try loading with thumbtacks.

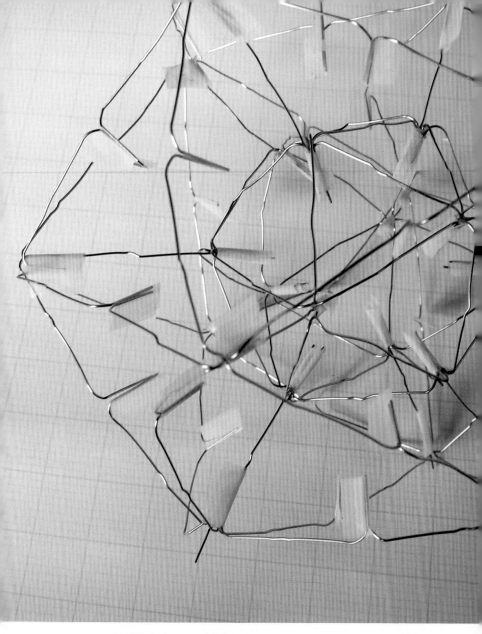

**PAPER CLIP TENSEGRITY SPHERE.** Tape may be used to connect the triangles for the inner and outer cores. A third, fourth, or fifth layer is recommended to grow the sphere.

# SIGNS

Once you have made and displayed your objects, it will be time to move on to monkey-wrenching the simplest of communication tactics: office signage. The best way to flex your manipulation skills is through a simple letter-sized sign that first mimics the existing micro-fascism in the office and then attempts to dismantle it. All of these signs project an unexplained—and grossly overly enthusiastic—sense of authority. Through careful wording and presentation, you can begin deploying your office "mates," causing them to unconsciously dismantle the office culture via imperative signage. An added bonus is the ability to pit staff against support staff. It is a fact that support staff will have already made a number of signs that infuriate and confuse all members of the office. Do not take down these signs. They establish the tone of the office's support staff microfascism. Use this tone as a starting point. Ratchet up the insanity. Later, amend signs to render them nonsensical.

**NEW PEOPLE**

**THIS APPLIES TO YOU**

**DO NOT TOUCH THESE!!!**

**OR WE HAVE TO RESET**

**THE FAX MACHINE**

| | |
|---|---|
| 9:00 a.m. | Never show up at this time |
| 9:05 a.m. | Respond to an email from home |
| 9:45 a.m. | Arrive at work; eat breakfast |
| 10:00 a.m. | Work on paper clip tensegrity sphere |
| 11:00 a.m. | Create letter-sized signs |
| 12:00 p.m. | Place signs |
| 1:00 p.m. | Leave for lunch |
| 2:50 p.m. | Return from lunch; check email and gossip blogs |
| 3:50 p.m. | Leave the office for coffee or snacks |
| 4:30 p.m. | Bring coffee and/or snacks back; check email |
| 4:00 p.m. | Continue work on tape ball |
| 5:00 p.m. | Go home |

**PLEASE BE
CONSIDERATE
AND WASH YOUR
DISHES**
DISHES LEFT IN
THE SINK WILL BE
THROWN OUT AT
THE END OF THE
DAY.

## To the individual whom stole the hotpockets!

They did not belong to you!
By you consuming said
hotpockets you have
committed a theft!

This shall not be tolerated!

Don't let all of my
talk about meeting
goals and
producing results
lead you into
unethical behavior.
You always have
my permission to
be "ethical".

Please Take
Your Paper
Out Of The
Copy
Machine And
Printer!!!
Thank You!)

Please
do not put
3 hole punch
paper in the
fax machine.

Thanks!

PLEASE HELP
TO KEEP THIS
ROOM CLEAN.
MANY THANKS.

"clean up"
after yourself!

Your MOTHER
doesn't work
here!

YOU MAY TAKE A
CUP OF WATER BUT
YOU MAY NOT FILL A
BOTTLE

Unplug
Refrigerator
After Use

| | |
|---|---|
| 9:00 a.m. | Never show up at this time |
| 11:30 a.m. | Arrive at work; eat breakfast |
| 12:00 p.m. | Leave and go see a movie |
| 2:30 p.m. | Return to the office; check email |
| 3:00 p.m. | Leave for lunch |
| 4:30 p.m. | Return from lunch; check email and gossip blogs |
| 5:00 p.m. | Go home |

# Only put **WHITE** paper in this bin. Thanks!

racist

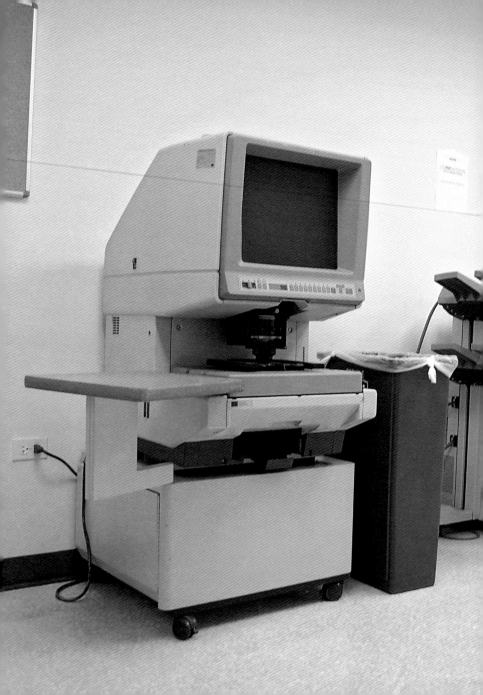

# ELEC- TRONICS, SABOTAGE, AND SURVEIL- LANCE

After a few weeks of strategic apathy, you will be able to begin working on more advanced tactics. It is crucial that you develop breadth and depth of strategies in the areas of office miscommunication. Familiarity with the basic techniques of electronic communications sabotage and digital "property" damage will give you the confidence to make your projects succeed. The following exercises lay the foundation for your invisibility and your sense of being dangerous to the system. The tools of office destabilization are all around you. Computers, clocks, copiers, and coffee machines—almost all the things that get plugged into a socket—are critical devices for the proper flow of both the micro- and macrofascisms of office culture. With these items, you can gather information, spread misinformation, hinder the flow of tyrannical information, and exponentially waste company time.

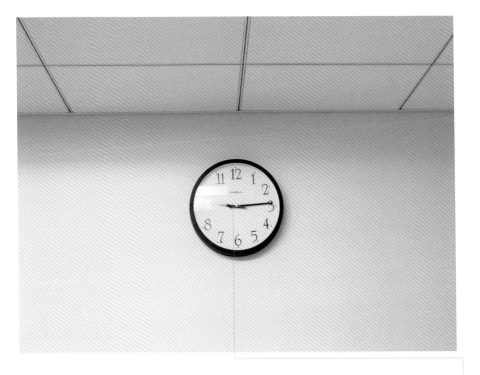

**THE CLOCK IS THE ENEMY OF THE OFFICE WORKER. IT MOCKS ANYONE WHO IS COUNTING TIME.** Time is money. There are two kinds of clocks you must monkey-wrench: wall clocks and computer clocks. Accordingly, there are two different results you want to achieve. A foot soldier or support staff is absolutely concerned with leaving the office precisely at quitting time, and therefore needs to believe that it's earlier than it actually is. An agent or junior staff member is ultimately concerned with being on time for work and for meetings, and therefore needs to believe that it's later than it actually is.

**Set the clock in the copy room an hour back and the clock in the lounge an hour forward.** If the lounge doesn't have a clock, you can use the one on the microwave, but make sure all "clocked" appliances are synchronized. Resetting a microwave clock can look like you're baffled about how to heat up your coffee; if you are caught resetting the wall clock, claim that you thought it was broken and that you were trying to fix it.

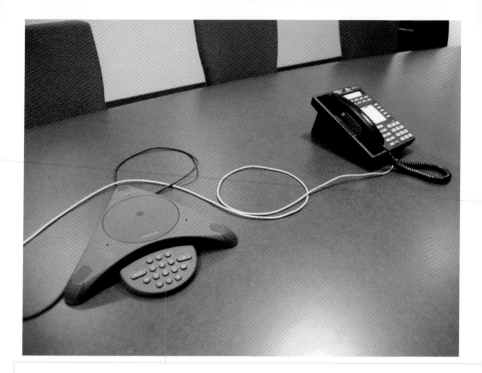

THE TELEPHONE HAS BEEN AN OFFICE STAPLE FOR A HALF-CENTURY. IT IS ONE OF THE BEST TOOLS FOR CREATING OFFICE MAYHEM. There are two separate systems to consider here: the general office phone, often answered by a foot soldier, and phones that are assigned to individual workers, often equipped with voice mail. Beginning to think about causing mayhem via telephone starts with a thorough understanding of why the device is an irritant to you and how it controls you. You can then use this analysis for your own gain.

1. For your outgoing voice mail, leave the longest away message allowed by the system. The longer people have to wait to hear your message, the less likely they will leave one.

2. Whenever possible, rather than emailing someone, use the telephone. To email someone is to say "Please pay attention to this when you have a minute." If instead you call repeatedly about the same

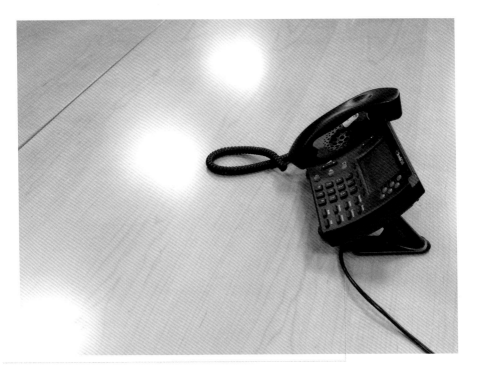

issue, you're saying "This is so much more important than whatever you're doing right now." Additionally, if you are fortunate enough to get someone's voice mail, take the opportunity to again leave the longest message allowed by the system.

3. **Read that telephone manual.** In it you will find all sorts of useful tools, beginning with the ability to forward your calls. Forward your calls to a different person each week. Because no one understands these systems, you can feign pie-eyed ignorance with impunity.

4. **Conference call anti-etiquette.** If no one understands the system in place, appoint yourself technician at the beginning of a conference call, and then spend at least twenty minutes trying to connect and dial people in. If you've read the manual, you can successfully disconnect the last person every time you add another one. During a conference call, talk as far away from the phone as possible, and in your usual voice. The meeting will be over before anyone figures out how to have one.

78% OF AMERICAN COMPANIES MONITOR THEIR EMPLOYEES IN SOME WAY. 63% OF EMPLOYERS MONITOR INTERNET USE; 47% STORE AND SIFT THROUGH EMPLOYEE E-MAIL MESSAGES; 15% KEEP TRACK OF EMPLOYEES BY VIDEO; 12% RECORD AND REVIEW PHONE MESSAGES; AND 8% REVIEW MESSAGES LEFT ON VOICE-MAIL.

PAY ATTENTION TO THE ITEMS LOCATED IN THE MEETING ROOM. THERE ARE IMPORTANT DISCUSSIONS AND CALLS THAT COULD AFFECT YOUR STATUS IN THE COMPANY. One of the most important parties in warfare is the intelligence division. You need to know what people are saying without getting sucked into the office culture.

Before an important meeting, go into the meeting room to place a call that "requires privacy." Call your own line and "forget" to hang up. It's the next best thing to being there.

Get to know the bigmouths in your office. It is useful to keep a chart of communication paths through the office (see page 55), as it is useful for receiving information and for spreading false information.

Bug the meeting room with a wireless microphone. This tactic is obviously useful to gain specific information only in dire circumstances, because it is strictly illegal, unless you are in charge.

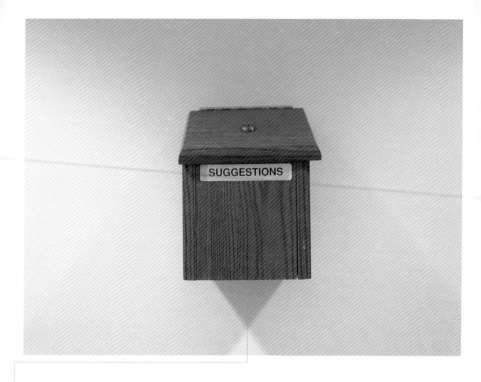

**UNLIKE EMAIL, THE SUGGESTION BOX IS ANONYMOUS, AND THE PERSON IN CHARGE OF IT IS LIKELY TO BE A LOUDMOUTH.** First, it is important to know who reads the contents of the suggestion box. Next, you want to ascertain where this information is headed. Since it is support staff who will likely intercept these communications, the suggestion box is best used to destabilize the already tenuous relations between support staff and regular staff. Sign other workers' names to your messages.

**It may be time for that office romance to go public.** There is no rule that says that you can only put written (or typed) messages in this box. A picture is worth a thousand words.

**Everyone wants to know.** Whatever your intelligence work has uncovered, from monetary information to future corporate strategy, this is the place to spread the word. Think of it as an open mike.

THE COPIER ROOM IS NOT JUST A GOOD PLACE TO SLEEP. IT IS A GOOD PLACE TO FIND OR LEAVE "FORGOTTEN" DOCUMENTS. THIS MACHINE IS ALSO COMPLICATED ENOUGH TO RUIN A JUNIOR STAFFER'S DAY. Similar to the suggestion box, anything found on the copier is fair game; similar to that expensive phone system, there is only one person who knows how to use it. And, like the printer, it's disputed territory.

If you are using the copier, fumble and take as long as possible. If anyone else is using it, stand behind them, fidget, and stare at your watch. Enforce a first-come, first-serve rule if you're there first, and a volume rule if you just walked into the room: always claim you have only one copy to make.

Change the copier settings as you leave the room. Get to know your copier: Changing the paper path or tray settings will cause more havoc than simply setting the number of copies to fifty.

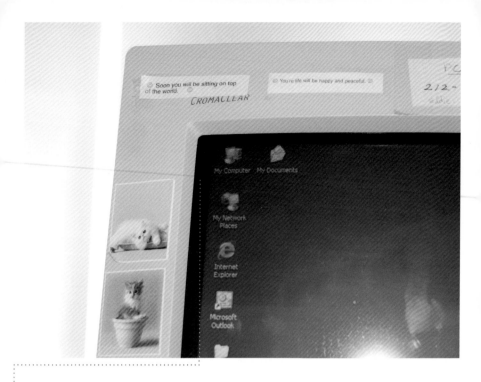

**COMPUTERS ARE YOUR MAIN WEAPON AND SURVEILLANCE DEVICE OF CHOICE IN THE OFFICE, BOTH FOR YOU AND YOUR ADVERSARIES.** All work and communication flows through computers. With enough technical knowledge and destructive desire, you can seriously disable your office, perhaps permanently. Beware of individuals who have either access or expertise in the realm of your computer network because they possess the power to destroy you.

**Type in the wrong password on a colleague's computer. Three times.** With most systems, this is enough to lock someone out. Do it repeatedly and they will think there is something wrong with the system. So will tech support.

**Send out that email address, click on pop-up windows.** Sign people up for greeting cards, surveys, porn sites, gambling sites—anything that will ensure that their email will be sold and distributed. If you have access to their computer, surf the Internet for sex tourism and click every banner ad.

**Take the system down.** Click on all of the links in your junk mail. Do the same on any computer you can safely and stealthily access. Hit "OK" in all pop-ups. Tie up IT staff by reporting ghost errors and mysterious data losses. Lacking a computer is a solid reason to do nothing while at work.

20% OF COMPANIES SECRETLY MONITOR EMPLOYEES' EMAIL, COMPUTER FILES, OR VOICE MAIL, AND THE PERCENTAGE IS HIGHER FOR COMPANIES THAT HAVE MORE THAN 1000 EMPLOYEES.

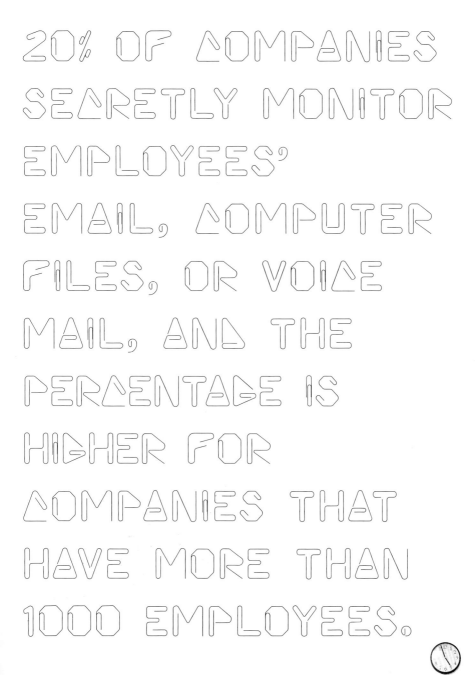

# KNOW YOUR SURROUNDINGS

Gathering intelligence is absolutely critical if you are to prevail in your goal of creating office mayhem. There are two things you need to know about each person in your office: when they are there and where they are. In terms of how these people relate to one another, you must keep careful tabs on communications, know who hates them— and why. This will change frequently, especially as employees leave and are hired. Keep a close eye on the control hierarchy. Record-keeping for a few weeks or months is recommended in order to ensure the success of any attack, especially if you are planning a communications attack. These include, but are not limited to, well-placed rumors and physical attacks. Discretion is important above all else. Use or copy the forms provided in this section to begin to develop your own intelligence framework.

| EMPLOYEE | LATE? | TIME | LOCATION |
|---|---|---|---|
| | | | |
| | | | |
| | | | |
| | | | |
| | | | |
| | | | |
| | | | |
| | | | |
| | | | |
| | | | |
| | | | |
| | | | |
| | | | |
| | | | |
| | | | |
| | | | |
| | | | |
| | | | |
| | | | |
| | | | |
| | | | |
| | | | |
| | | | |
| | | | |
| | | | |
| | | | |
| | | | |
| | | | |
| | | | |
| | | | |
| | | | |
| | | | |
| | | | |
| | | | |
| | | | |
| | | | |
| | | | |
| | | | |
| | | | |
| | | | |

RECORD-KEEPING LOG: MAKE SURE TO COPY FOR FUTURE USE.

POWER HIERARCHY. KEEP A BLANK CHART HANDY FOR UNEXPECTED CHANGES.

OFFICE LAYOUT: MAP OUT YOUR POINTS OF ATTACK.

KEY INSIDE

IN CASE OF
EMERGENCY
BREAK GLASS

MMF
INDUSTRIES

# NATURAL, NON-LETHAL, AND LETHAL WEAPONS

# ARSENAL

Just as the best way to seed your communications abilities is through the simple letter-sized sign, you will want to master a variety of ways to inflict physical damage on persons and things you deem antithetical to the project of destroying office culture and, with that, life as we know it in the Western world. As most freedom fighters are peaceful, the items you will be creating for your arsenal must seem terrifying. The scarier the weaponry, the less likely it is that anyone will mess with you.

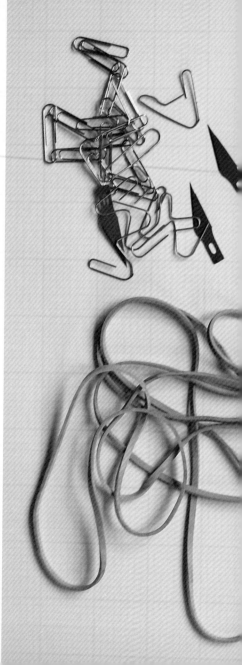

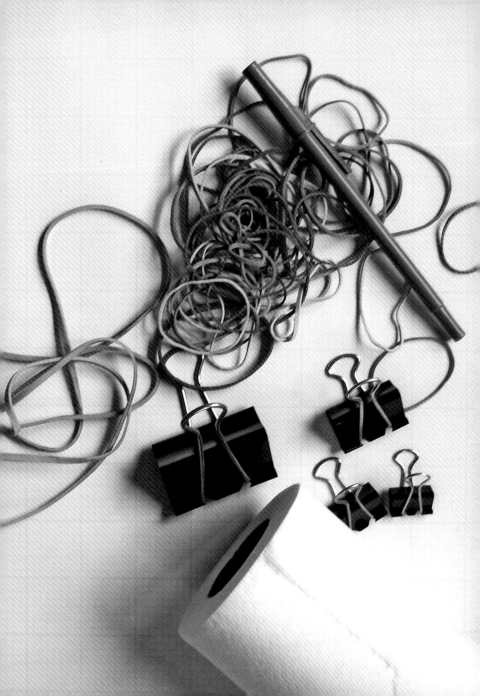

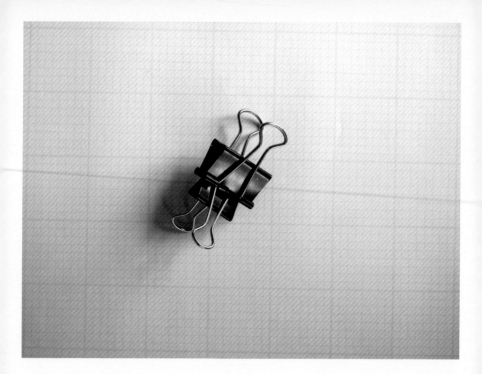

# THE MINI DOUBLE BINDER CLIP SHOOTER.

The Mini Double Binder Clip Shooter is the smallest in the office armory and is therefore the most discreet. Its parts can be transported into a meeting without any notice, and can be built in less than ten seconds. This shooter is one of the sharpest, and has a range of up to twenty feet (seven meters). The Mini Double Binder Clip Shooter is ideal for a target at the end of a boardroom table.

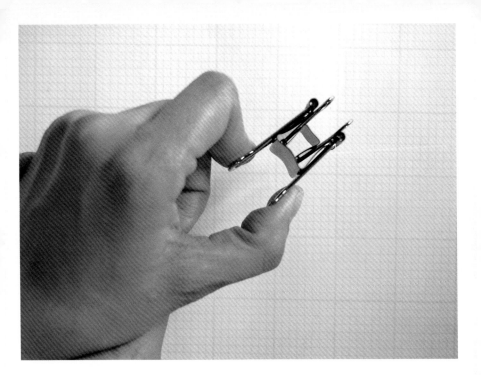

To assemble the Mini Double Binder Clip Shooter, simply open a medium binder clip and insert a small binder clip. As this creates an unstable situation, use care. It helps if the larger "launcher" clip is not brand new. Push the small binder clip into the large clip, tensor-side facing out. Release tensors, thereby opening smaller "launcher" clip. Hold it firmly in place. To launch the shooter, aim and release.

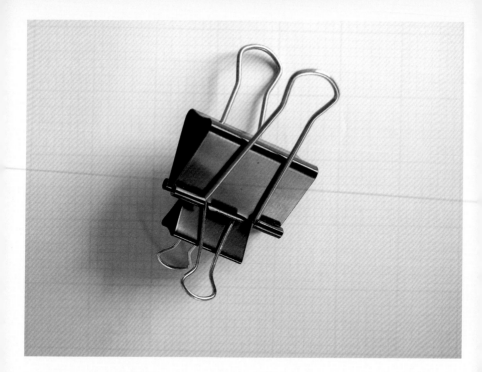

# THE JUMBO DOUBLE BINDER CLIP SHOOTER.

The Jumbo Double Binder Clip Shooter is more appropriate for cubicle-to-cubicle combat. While the impact of the Jumbo Double Binder Clip Shooter is significant, it also requires a great deal of practice to assemble quickly and fire accurately. This shooter has a range of up to sixteen feet (five meters). Deploying it close-range is recommended only in life-or-death situations.

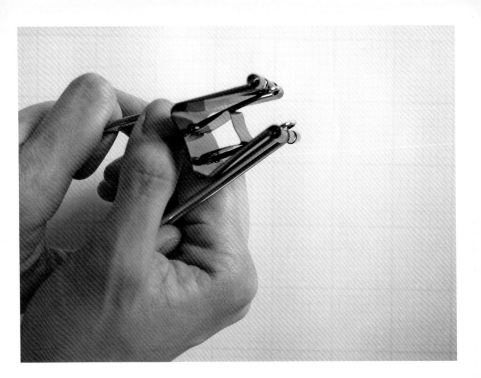

To assemble the Jumbo Double Binder Clip Shooter, open the jumbo binder clip and insert a medium binder clip. Push the medium binder clip into the center of the jumbo binder clip and hold it in place. To launch the shooter, aim and release, holding the handles as necessary.

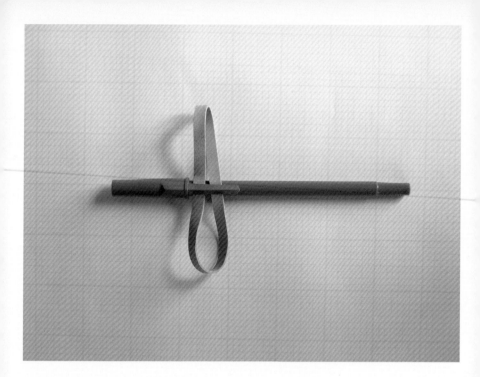

# THE INK-AND-RUBBER SUPER-SHOOTER.

The Ink-and-Rubber Super-Shooter hurts. This powerful weapon is even more damaging when a thick rubber band is utilized. It is also one of the easiest weapons to keep on hand: An arsenal of pens and rubber bands will arouse little or no suspicion. Even better, the Ink-and-Rubber Super-Shooter is easy to hide, easy to load, and easy to fire. This shooter is good for hallway attacks because it has a range of up to forty-four feet (sixteen meters).

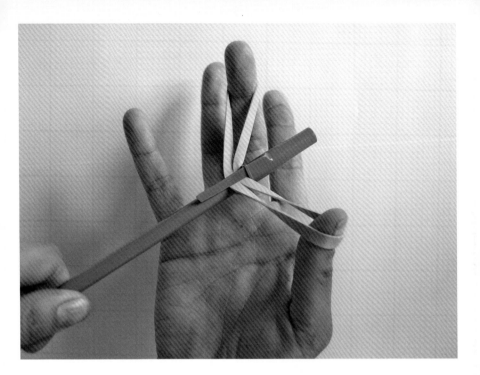

To assemble the Ink-and-Rubber Super-Shooter, hold the rubber band between your middle finger and your thumb. Keep your middle finger and your thumb as far from the other as possible. Pull the rubber band under the pen cap. Then, tighten the cap of the pen and pull the pen back, pointing it at your target. With the thumbnail of the retracting hand, nudge the cap when maximum rubber band tension has been achieved. Thus released, the cap will rotate in the air and hit your target full-force.

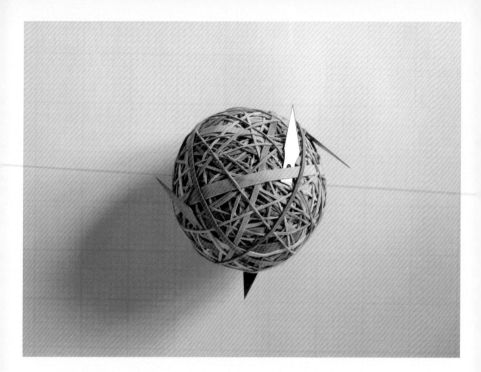

# OFFICE MAYHEM RUBBER BAND MACE.

The Office Mayhem Rubber Band Mace is going to be a tough one to explain if anyone in the office finds it, so hide it carefully. If launched from a close distance, it will most certainly put out an eye, stab into flesh, or slice open the top of a white collar-swaddled neck.

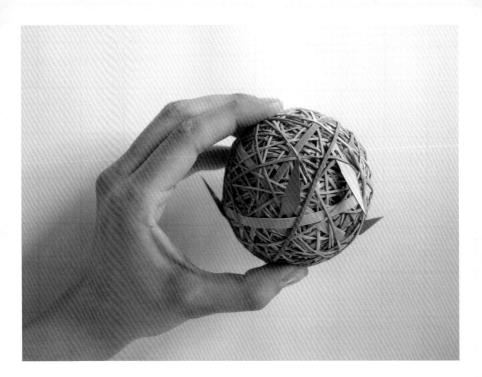

This weapon should be constructed in advance. Coworkers may try to borrow rubber bands from your rubber band ball. This should not be an issue if you keep it out of sight in a desk drawer. It is possible to add the razor blades in less than a minute, once you've invested a little strategic-apathy time working on technique.

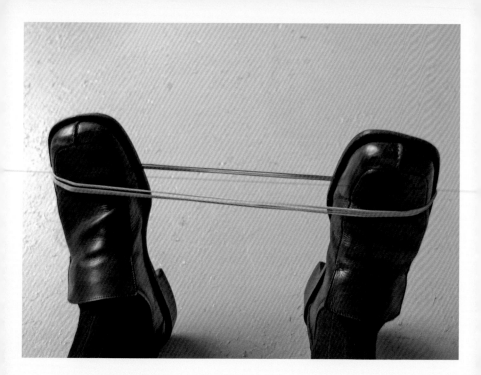

# TOILET-PAPER SLINGSHOT.

The Toilet-Paper Slingshot is a fantastic way to darken the moods of both regular and support staff, in that it suggests the presence of an unstable personality. For this weapon you will need a Tupperware container of water (concealed somewhere handy), one half-used roll of toilet paper, and six no. 177-sized rubber bands. (Bosco chocolate syrup optional.) Shoots thirty feet (nine meters).

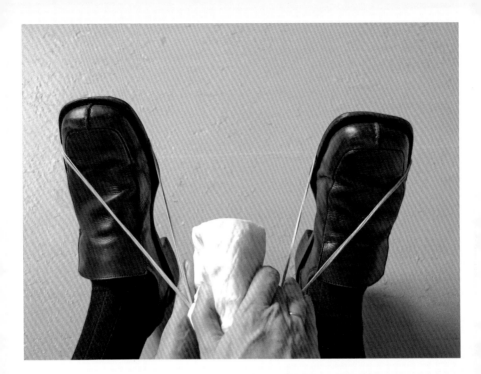

Fill a Tupperware container with water and add the half-used roll of toilet paper. Sitting on the floor, loop the rubber bands around your shoes to create slingshot. Place toilet paper against rubber bands, dowel-end facing you. Pull back. Fire.

# EXPLO-SIVES AND BOOBY TRAPS

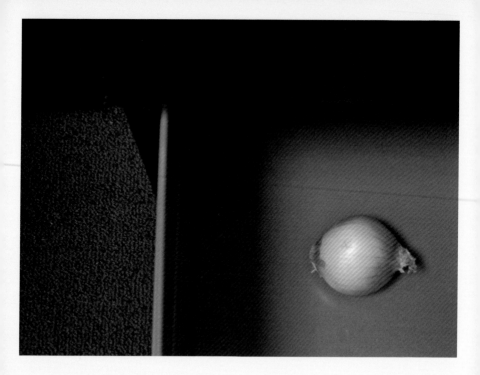

# ONION STINK-BOMB.

You have mastered both communications and ground-combat tactics. You have a system for keeping track of time, space, and relationships. Now you must move on to more disruptive strategies. Remember that where you work is not just a workplace, but a shared office environment. Shared spaces, such as breakrooms, hallways, elevators, and bathrooms, afford many opportunities for mayhem. They usually provide a surprising level of privacy and your work here requires only a few common items that will most likely arouse no suspicion. The way the modern office works, many behaviors, such as eating or drinking in the office, are also condoned or even encouraged. And because personalizing your office can be interpreted as a sign of loyalty, it is looked upon in a positive light. You can bring practically anything you like into this

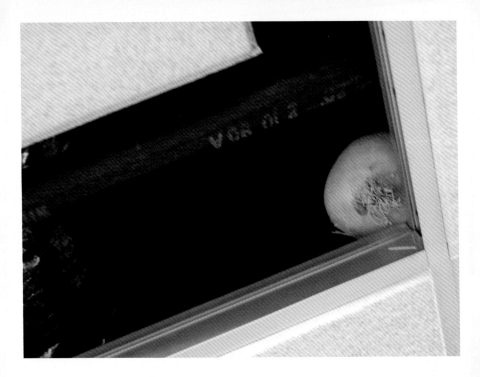

space. Employers are very much invested in your spending as much time as possible in your work environment. "Think of it as your home." That is the credo. It is not your home. It is a place that exerts a massive amount of control over you, and controlling this environment is what it's all about.

The primary shared item in this space is the air. AN ONION PLACED IN ANY HIDDEN LOCATION WILL BEGIN TO SMELL LIKE A CORPSE WITHIN A FEW WEEKS. IF YOU HIDE ONE ABOVE THE CEILING TILES, THE MOST LIKELY OUTCOME WILL BE AN EXTERMINATOR VISIT AND POTENTIALLY AN EVACUATION. Hide one in a vent to really wreak havoc.

# OLD FASHIONED STINK BOMB.

Because the scent of anything introduced into the air will spread quickly, the sources of any given odorant is difficult to determine—and people already possess a certain level of paranoia about the air in their offices. It's not only "bad" smells that will assert your authority over the office environment, any kind of olfactory assault will be sufficiently disruptive. TO CONTROL THE AIR OVER TIME, PURCHASE A CASE OF AIR FRESHENERS, PREFERABLY THE PLUG-IN VARIETY. PLACING TWO OR THREE IN YOUR WORKSPACE EACH WEEK CAN ENSURE THAT YOUR OFFICE SMELLS LIKE COCONUT FOREVER. MEANWHILE, IT APPEARS AS IF A GOOD SAMARITAN IS ZEALOUSLY LOOKING AFTER THE OFFICE. While the longest-lasting results are achieved

HOMICIDE IN THE
WORKPLACE IS
THE #1 CAUSE
OF DEATH AMONG
FEMALE WORKERS
IN AMERICA AND IS
THE #2 CAUSE OF
DEATH FOR MALE
WORKERS.

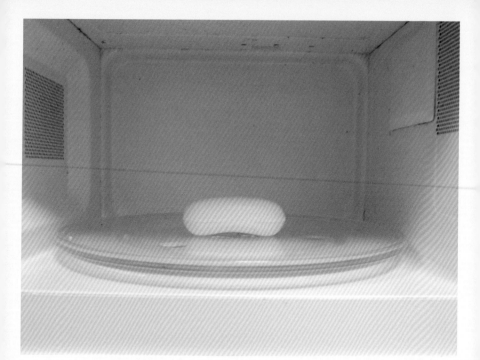

# SOAP BOMB.

over extended, calculated periods, you may be in a situation where you only have a few minutes or even seconds to play things out, such as if you gain temporary access to another part of your company. An early entrance and a prior stakeout will put you in a situation where you can cause an evacuation within minutes. **PURCHASE A PERFUMED BAR OF SOAP, PREFERABLY LAVENDER, AND KEEP IT IN YOUR BAG. WHEN THE OPPORTUNITY ARISES, ALL YOU HAVE TO DO IS POP IT INTO THE MICROWAVE AND SET IT TO BAKE FOR 30 MINUTES.** The microwave is useful for far more than olfactory offenses; pretty much anything placed in it can become hazardous. Most things have the potential to explode in this environment; anything that has no way to expand, such as an egg or a

completely sealed container, is a good candidate for testing. You can experiment with a number of items. With enough discretion, you will get nothing more than another collection of letter-sized signs. Be absolutely careful, however, with metallic items. Batteries, especially D-sized batteries, will cause the microwave to explode; cans of spray paint will also make this machine explode. You may want to disrupt quickly, but with a long delay. Match heads thrown into a jar, or ammonia (both of which you will likely find in your office), will turn into an effective stink bomb that smells like rotten eggs within a week. If you'd like to combine those effects with an explosion, however, biological methods are best, and because food is considered to be an innocuous part of office life, it's easy to bring together the materials necessary for an explosion that

AN ESTIMATED $50
BILLION DOLLARS
ARE LOST EVERY
YEAR DUE TO PRO-
DUCTIVITY LOSSES
ATTRIBUTED TO SICK
BUILDING SYNDROME.
AROUND 2% OF
OFFICE WORKERS
REPORT SYMPTOMS.

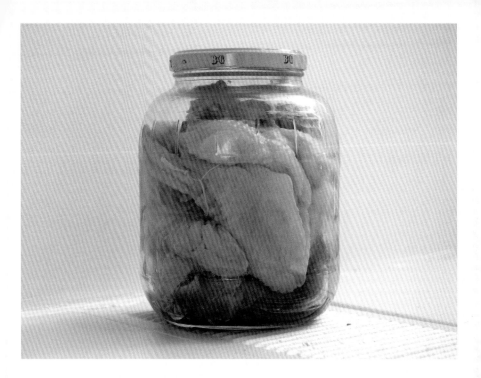

# ΛHIΛKEN ᗷOMᗷ。

no one will ever forget. While it can be created with practically any kind of meat, fish, or poultry, the "chicken" bomb is hands-down the most potentially disgusting thing you can inflict on a group of people—ever. PLACE A WHOLE CHICKEN IN A PICKLE JAR AND SET IT IN A WARM, DISCREET PLACE, PREFERABLY ON OR NEAR A RADIATOR. ONCE THE NATURALLY OCCURING GASES HAVE DEVELOPED SUFFICIENTLY, THE JAR WILL EXPLODE, PROPELLING DECOMPOSED CHICKEN OVER A CONSIDERABLE AREA. This can also be turned to your advantage in a coordinated attack, though it is not guaranteed that all of the chicken bombs will go off on the same day. The downside of setting up these bombs is that they point to intent; it is definitely more useful in a

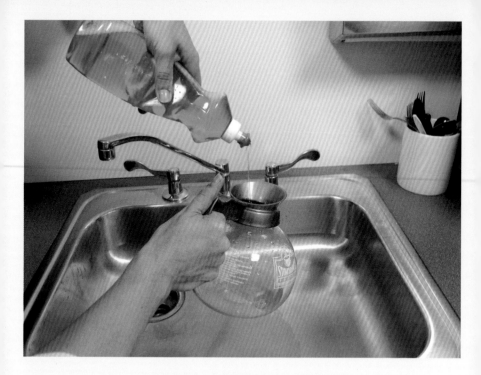

# SOAP IN THE COFFEE
# BOOBY TRAP.

work situation where there are hundreds, rather than dozens, of employees, and if you have just left the office, either by quitting or being fired, you will have to be careful to cover the association between the explosion and your departure.

You may find that day-to-day biological attacks are both easier to accomplish and easier to conceal, even if they limit your targets, unlike the air assaults described earlier. COFFEE IS EASY TO TAMPER WITH. IN MANY OFFICES, IT'S EVERYONE'S RESPONSIBILITY TO MAKE IT. IF YOUR COFFEE MAKER IS IN A COMPANY KITCHEN, IT IS ALREADY CLOSE TO YOUR MOST EFFECTIVE COFFEE ADDITIVE: SOAP. SIMPLY ADD A LARGE QUANTITY

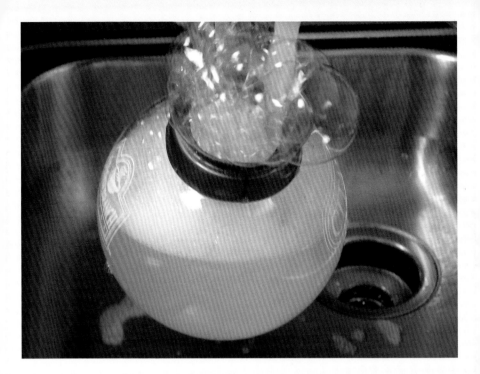

**OF SOAP TO THE POT, DO NOT RINSE COMPLETELY, AND PROCEED TO MAKE THE COFFEE.** Soap is an insidiously effective diuretic and laxative, and when combined with the already existing diuretic and laxative qualities of coffee, it can easily send people home. Better yet, the destruction wrought via soap and coffee can be written off as sloppiness—you are "washing" the pot. The downside to this method is that it is likely only a one-day attack. Workers will learn to avoid tainted coffee. Look around for other opportunities when people are shy about the coffee— people tend to feel far more secure about water coolers, cups, and third-party items. Spreading paranoia about these items can be almost as effective as tampering with them, since these shared areas are administered by support staff and thus already

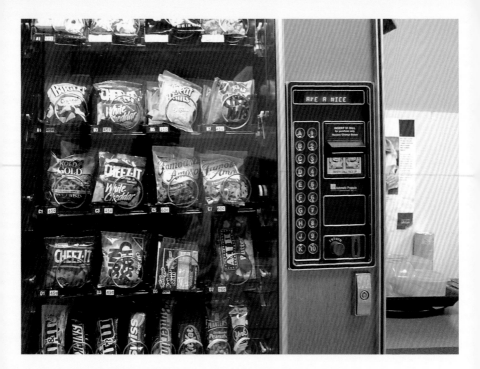

# VENDING MACHINE TRAP.

raise suspicions amongst the remaining employees. Combining rumors with cleverly worded—and placed—signs can potentially spark a time-consuming civil war in the workplace between the help and the "help." Playing on the desires and fears of office workers can also spark disorder, especially when dealing with mysterious third-party items, such as vending machines. VENDING MACHINES SO RARELY WORK PROPERLY THAT THEY CAN ACCOMPLISH MAYHEM ALL ON THEIR OWN. TELL SOMEONE A "SECRET" ABOUT HOW TO TIP OR ROCK THE MACHINE TO OBTAIN FREE CANDY; ALTERNATELY, YOU MAY "DEMONSTRATE" A WAY TO PUSH YOUR ARM UP INTO THE MACHINE. The vending machine, to the employee, is a sign that the employer is too cheap to provide the materials within;

IN THE LAST TWO DECADES, AT LEAST 35 PEOPLE HAVE BEEN KILLED AND 140 HAVE BEEN INJURED IN THE USA BY TOPPLING VENDING MACHINES.

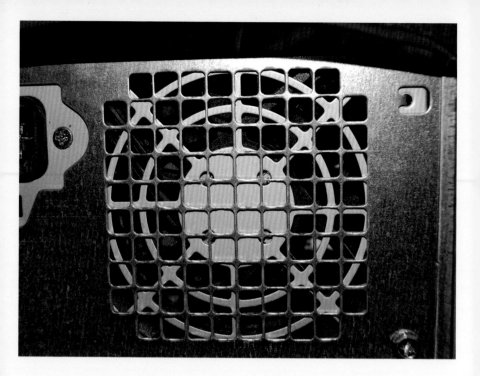

# ᴄOMPUTER FAN ᗷOOᗷY TRAP.

thereby he or she will go to any length to extract items from it without paying for them. This is an easy one-on-one tactic if you have a specific target with an appropriately sized ego and a sense of competition. Stating that you have done it will be enough.

The other machine that has the ability to mystify and derail things all by itself is, of course, the computer, but in more ways than as discussed earlier. It is a very hot machine, requiring one or more fans to keep it from overheating. IF YOU CLIP ONE OR MORE WIRES THAT POWER THE FAN, THE COMPUTER WILL FAIL TO COOL, RESULTING, AT MINIMUM, IN SERIOUS HARD DRIVE FAILURE. The impact of this operation will be somewhat unpredictable, as the

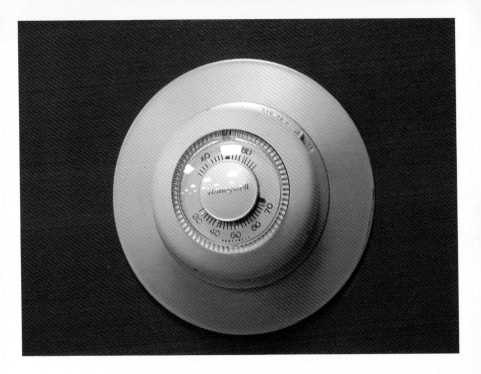

# A/C BOOBY TRAP.

computer may begin to emit smoke as well. If you don't want to risk wire-clipping, simply bending the blades of the fan will be enough to cause the computer to hum whenever the fan runs. This buzzing, combined with the buzz of the fluorescent lights, may incapacitate certain office workers.

Smell and sound are not the only senses that are vulnerable. According to the International Facility Management Association in Houston, Texas, the number-one complaint in offices is that they are too cold; the number-two complaint is that they are too hot. **IF IT'S SUMMER, MAKE IT TEN DEGREES COLDER. IF IT'S WINTER, MAKE IT TEN DEGREES HOTTER.** If you can't access a mechanical

Unplug
Refrigerator
After Use

# UNPLUG REFRIGERATOR BOOBY TRAP.

thermostat, get on the phone with the support staff member who is in charge of the temperature—three times a day. You're better off, however, mounting an attack once or twice a season—more frequent calls will mark you as a troublemaker. Passive-aggressive notes, again, are a far more reliable way to get your office "mates" to do the work of monkey-wrenching for you. The refrigerator is almost guaranteed to be the center of someone's attention, so anything pasted on it seems perfectly natural and absolutely threatening. **WITH THIS PLATFORM, YOU CAN GET PEOPLE TO LOWER OR RAISE THE THERMOSTAT WITHIN THE REFRIGERATOR, DEFROST THE FREEZER, OR UNPLUG IT ENTIRELY.** The refrigerator is a deep-storage device used to halt the decay of food that should be thrown away.

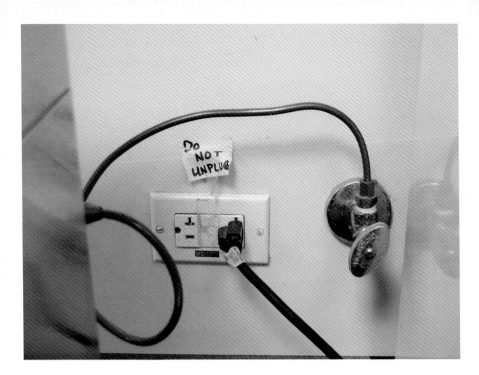

Successful action here will create a bio-disaster within a day or so. Of course, a stealthier and more reliable way to accomplish the same thing is to simply be the first person at work and the last person to leave each day. Just plug the refrigerator in when you come to work and unplug it when you leave. **THE REFRIGERATOR IS A MECHANICAL APPLIANCE. THEREFORE, ANYTHING THAT GOES WRONG WITH IT WILL BE ATTRIBUTED TO A WIDE SET OF SUSPICIONS.** If you stay under the radar, you can put enough "sugar" in the "gas tank" of the machine to bring it to a halt, especially if you are working patiently and persistently, and you are watching people carefully. Everything that will disrupt that system is already in place: All you have to do is pay attention, and get involved! Now get to "work."

# DISCLAIMER, BIBLIO- GRAPHY, AND ACKNOW- LEDGMENTS

# DISCLAIMER

The views expressed in this book are the views of the author and do not reflect the views of Harry N. Abrams, Inc. The information contained in this book is presented solely for entertainment purposes. In no event shall Harry N. Abrams, Inc., assume liability for any direct, indirect, incidental, consequential, special, or exemplary damages arising from the use or misuse of the information contained in this book, whether based on warranty, contract, tort, or any other legal theory, and whether or not the company is advised of the possibility of such damages.

# BOOKS

Jensen, Derrick and George Draffan. *Welcome to the Machine: Science, Surveillance, and the Culture of Control.* Chelsea Green Publishing Company, 2004.

Jensen, Derrick. *The Culture of Make Believe.* Context Books, 2002.

Fromm, Erich. *The Anatomy of Human Destructiveness.* Owl Books; New edition, 1992.

Hanh, Thich Nhat. *Anger: Wisdom for Cooling the Flames* Riverhead Trade; Reprint edition, 2002.

Kearney, Richard. *Strangers, Gods and Monsters: Ideas of Otherness.* Routledge; 1st edition, 2002.

Van Scott, Miriam. *Encyclopedia of Hell.* St. Martin's Griffin, 1999.

Duncan, Glen. *I, Lucifer: Finally, the Other Side of the Story.* Grove Press, 2003.

Bradbury, Ray. *Fahrenheit 451.* Del Rey; Reissue edition, 1987.

Orwell, George. *Animal Farm.* Signet Classics; 50th Anniversary edition, 2004.

Smith, Betty. *A Tree Grows in Brooklyn.* Perennial Classics; 1st Perennial Classics edition, 1998.

Alexander, Lloyd. *The Gawgon and the Boy.* Puffin; Reprint edition, 2002.

Alexander, Lloyd. *Dream-of-Jade: The Emperor's Cat.* Cricket Books, 2005

Fields-Babineau, Miriam. *Cat Training in 10 Minutes.* TFH Publications, 2003

Johnson-Bennett, Pam. *Think Like a Cat: How to Raise a Well-Adjusted Cat—Not a Sour Puss.* Penguin, 2000.

Johnson-Bennett, Pam. *Cat vs. Cat: Keeping Peace When You Have More Than One Cat.* Penguin, 2004.

Zobel-Nolan, Allia and Nicole Hollande. *Women Who Love Cats Too Much.* Adams Media Corporation, 1995.

Silver, Burton and Heather Busch. *Why Cats Paint: A Theory of Feline Aesthetics.* Ten Speed Press; Pocket edition, 2006.

# WEBSITES

www.celebrity-babies.com
www.celebutaint.com
www.defamer.com
www.drudgereport.com
www.egotastic.com

www.fametracker.com
www.gawker.com
www.gofugyourself.com
www.goldenfiddle.com
www.gossipcentral.com
www.gothamist.com
www.hollywoodrag.com
www.hollywoodtuna.com
www.hotonlinenews.com

www.huffingtonpost.com
www.idontlikeyouinthatway.com
www.infdaily.com
www.jossip.com
www.justjared.com
www.pagesix.com
www.perezhilton.com

www.pinkisthenewblog.com
www.popsugar.com
www.popbytes.com
www.thebosh.com
www.thegossipist.com
www.thejay.com

www.theshowbizshow.com
www.thesuperficial.com
www.wonkette.com
www.wwtdd.com
www.yeeeah.com

# AAKNOWLEDGMENTS

Many thanks to Eva Prinz for bringing this project into being and for the stash book, Mark Wasiuta for his advice, Karen Bianchi for her help with photography, Garrett Morin for the chicken bomb, Jean Servaas for the tape ball and for pitching in when we came down to the wire, Rob Trostle for brainstorming and tireless assistance, and Beau Friedlander for bringing this project home.

Some of the weapons in the armory were designed by Espen Arnesen, Geir Bjerke, and Glenn Thomas Hvidtsten of officeguns (officeguns.com), and others were inspired by their efforts. The paper clip sphere was adapted from Justin Schlecher's Icosaspark (paperclipart.com) and the trebuchet design was adapted from Scissorman's instructions at instructables.com.